Lands

C000136245

Powerful images taking you to ... y around Wales – from climbing the spectacular mountains of Snowdonia and surfing on the dramatic Pembrokeshire coast to the gentler attractions of the lowlands and idyllic river valleys. Written by David Williams. Published by Graffeg.

Contents

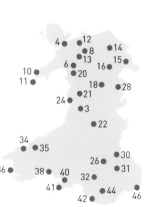

GRAFFEG

Introduction

Visitors to Wales have long appreciated the wealth of attractive and accessible landscape to be found within the compact dimensions of this fascinating country. Imposing mountains, sheltered valleys, glittering lakes, chuckling streams, silent forests and tidy fields give shape and character.

The land, as we see it today, represents a two-way process. Firstly, its relative remoteness has, over many centuries, shaped the individuality of the people who live and work here, and enabled their vibrant culture to survive. Secondly, the hand of mankind has tamed much of the terrain through farming, forestry, quarrying, mining and other occupations on and beneath its surface.

Farming remains the most visible industry – around 80% of Wales owes its appearance to agriculture. Our farmers excel at delivering produce of the highest quality, which is now winning a world-wide profile, while recognising the importance of maintaining a balance with nature.

Rural Wales is home to a diverse and advanced economy, while industrial communities enjoy a dramatic natural backdrop.

Tourism, one of Wales's major industries, celebrates the outstanding attractiveness of the landscape and encourages active enjoyment of the great outdoors. Our terrain provides the perfect challenge for the world's leading rally drivers.

Whether you seek adventurous pursuits or more gentle pleasures, Wales has many excellent places to stay and provides tremendous opportunities to participate in open-air activities and interests.

The quiet joys of a country walk, birdwatching or pony trekking – or the thrills of surfing, sailing or mountaineering – all give a very real sensation of being close to nature, while extending your knowledge and skills into new realms.

Mynach Falls
On sunny days, Mynach Falls at Devil's Bridge makes rainbows between damp rocks covered in lush vegetation.

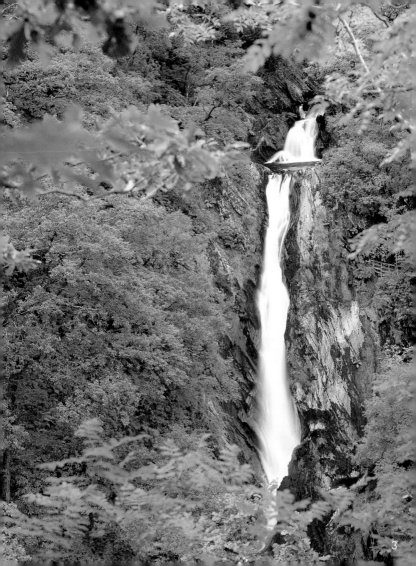

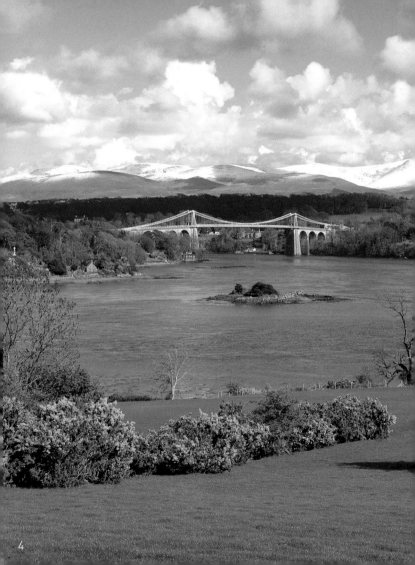

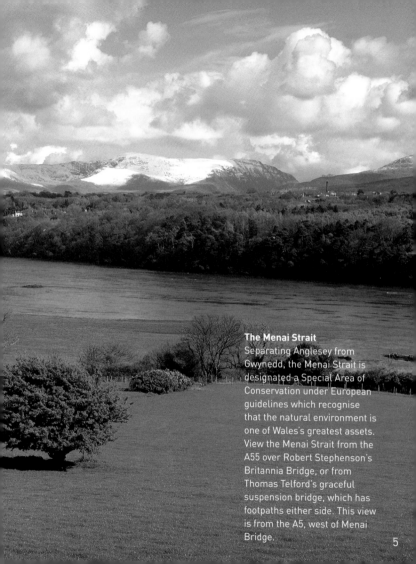

The Menai Strait
Separating Anglesey from Gwynedd, the Menai Strait is designated a Special Area of Conservation under European guidelines which recognise that the natural environment is one of Wales's greatest assets. View the Menai Strait from the A55 over Robert Stephenson's Britannia Bridge, or from Thomas Telford's graceful suspension bridge, which has footpaths either side. This view is from the A5, west of Menai Bridge.

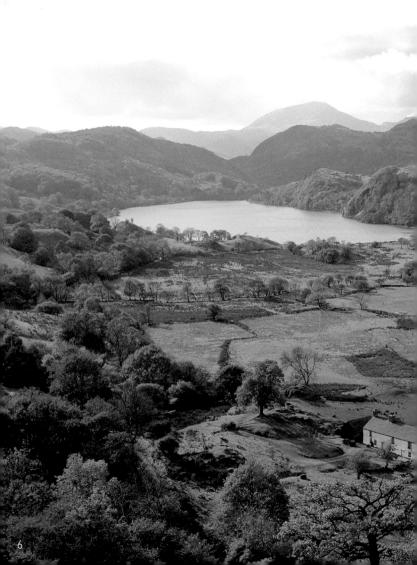

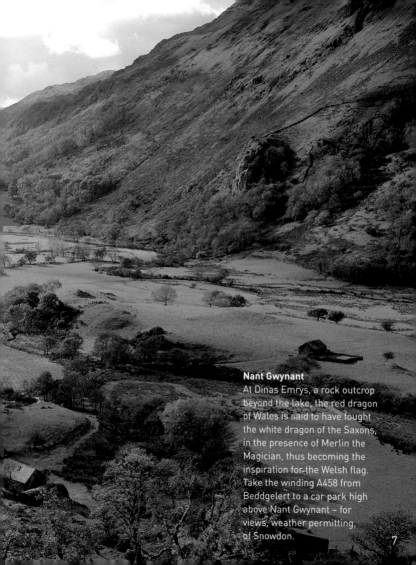

Nant Gwynant
At Dinas Emrys, a rock outcrop beyond the lake, the red dragon of Wales is said to have fought the white dragon of the Saxons, in the presence of Merlin the Magician, thus becoming the inspiration for the Welsh flag. Take the winding A458 from Beddgelert to a car park high above Nant Gwynant – for views, weather permitting, of Snowdon.

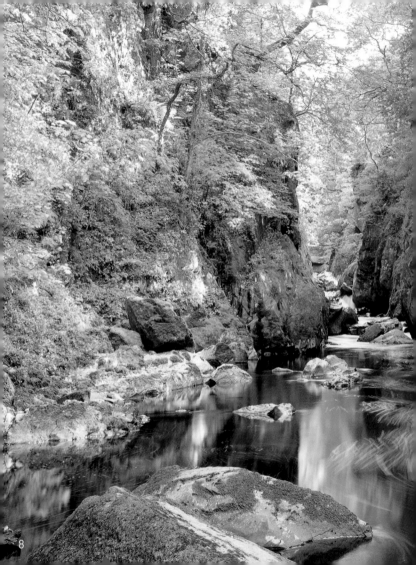

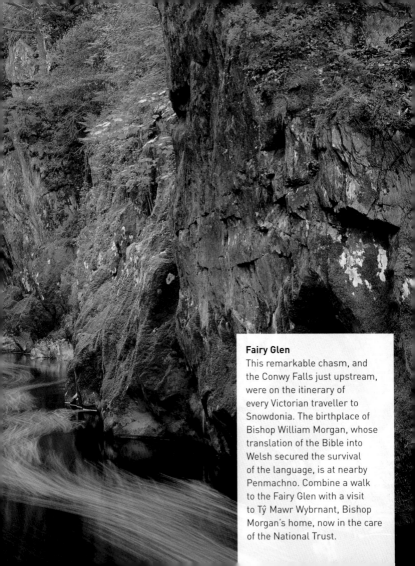

Fairy Glen
This remarkable chasm, and the Conwy Falls just upstream, were on the itinerary of every Victorian traveller to Snowdonia. The birthplace of Bishop William Morgan, whose translation of the Bible into Welsh secured the survival of the language, is at nearby Penmachno. Combine a walk to the Fairy Glen with a visit to Tŷ Mawr Wybrnant, Bishop Morgan's home, now in the care of the National Trust.

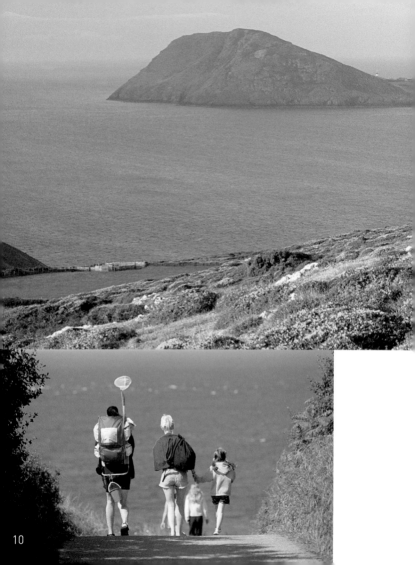

Whistling Sands
This family has all the essentials for a great day at the beach. Whistling Sands is named for the squeaking sound made by the coarse sand if you shuffle through it.

Bardsey Island
Mystical Bardsey has long been a place of pilgrimage – three journeys here equalled one to Rome. In settled weather, when the tide is right, it is possible to cross by boat from Aberdaron.

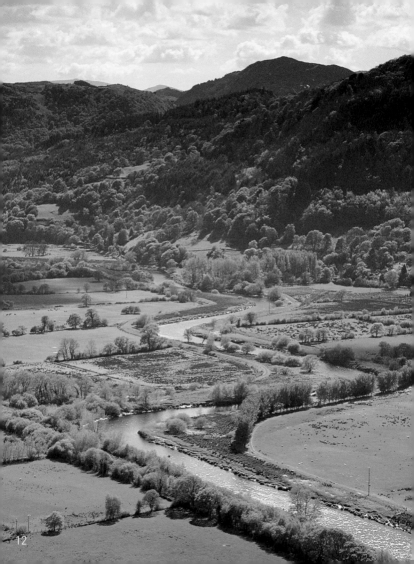

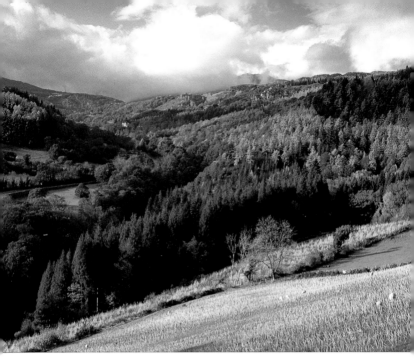

Conwy Valley near Trefriw
The floor of the Conwy Valley is fertile farmland, while the slopes bordering Snowdonia are fine walking and mountain-biking country. At Trefriw, iron-rich water, from springs discovered by the Romans, supplies a health-giving spa. Highlights of the lower Conwy Valley include the woollen mill at Trefriw and Bodnant Garden, one of the very best in Wales.

Forestry, near Betws-y-coed
Large tracts of upland Wales are given over to commercial forestry. Where once the policy was to plant blocks of a single species, the trend is now toward growing a variety of trees in more natural-looking plantations. Many forest tracks are open to walkers and cyclists, and the Forestry Commission runs some excellent campsites.

Clwydian Hills

The Clwydian range includes this region's most significant summit, Moel Famau, at 1,820ft. The Offa's Dyke long-distance footpath traverses these hills before descending to the coast at Prestatyn. Visit Loggerheads Country Park to learn about the natural history and industrial heritage of Flintshire.

Wrexham, sheep auction

The auctioneer calls out rapid volleys of prices as sheep are paraded in the ring and buyers decide how high they will bid – a scene repeated many times a week throughout Wales. Look out for the farmers' produce markets, which are an increasingly popular way of buying directly from the source – or visit the covered market in Wrexham.

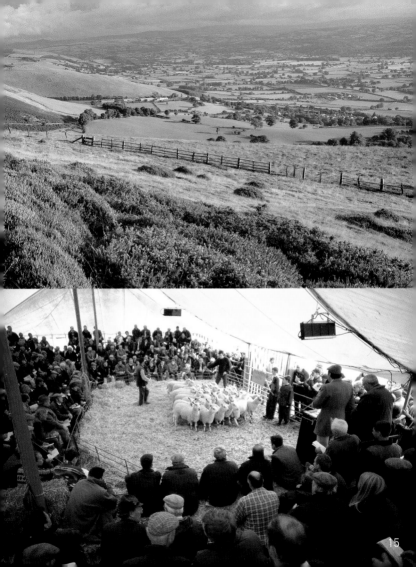

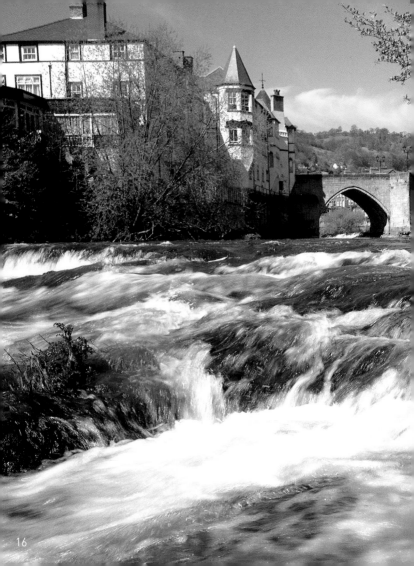

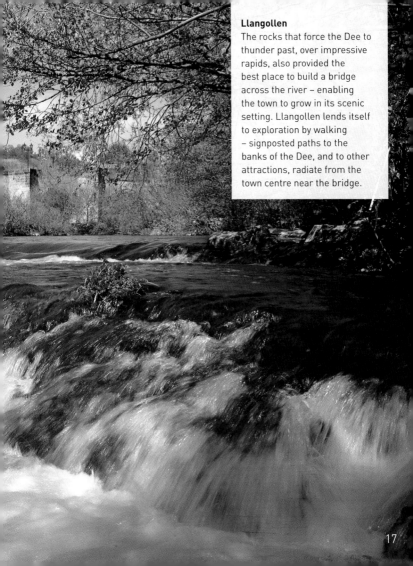

Llangollen

The rocks that force the Dee to thunder past, over impressive rapids, also provided the best place to build a bridge across the river – enabling the town to grow in its scenic setting. Llangollen lends itself to exploration by walking – signposted paths to the banks of the Dee, and to other attractions, radiate from the town centre near the bridge.

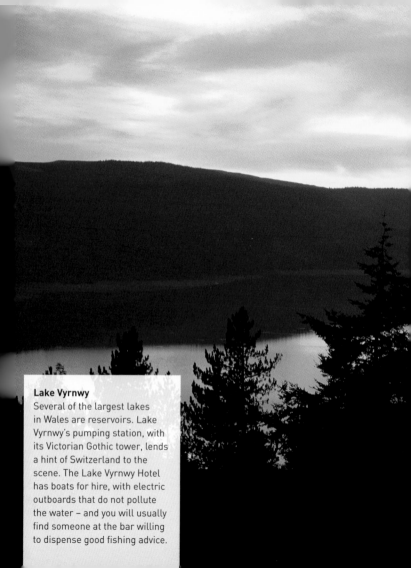

Lake Vyrnwy
Several of the largest lakes in Wales are reservoirs. Lake Vyrnwy's pumping station, with its Victorian Gothic tower, lends a hint of Switzerland to the scene. The Lake Vyrnwy Hotel has boats for hire, with electric outboards that do not pollute the water – and you will usually find someone at the bar willing to dispense good fishing advice.

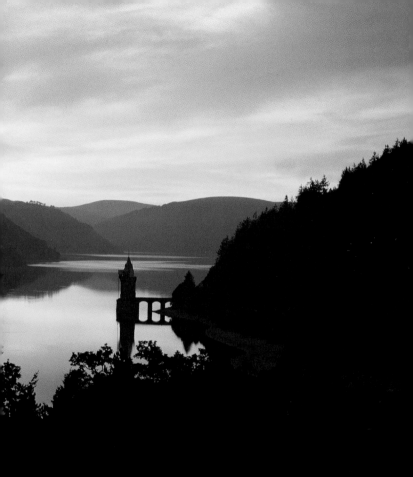

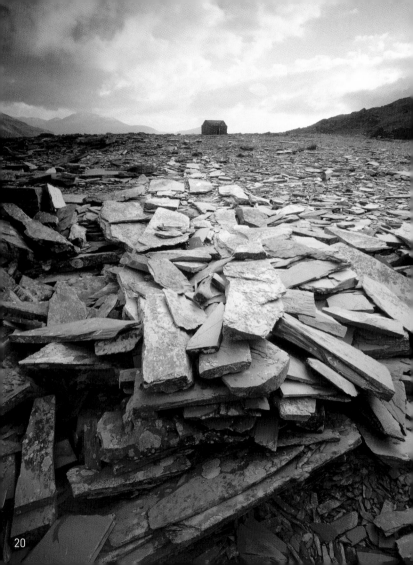

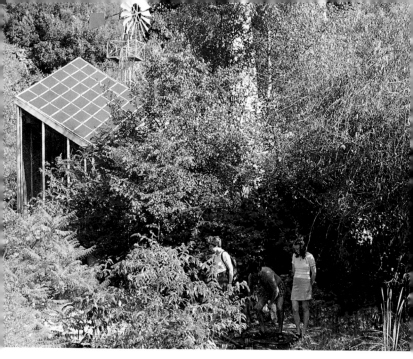

Cwm Croesor

Thousands of workers once laboured in the slate quarries and mines of Bethesda, Llanberis, Blaenau Ffestiniog and Corris. The underground tours at Llechwedd Slate Caverns, Blaenau Ffestiniog and the Welsh Slate Museum at Llanberis both give insights into the lives of slate quarry workers.

Corris, CAT

The Centre for Alternative Technology, between Machynlleth and Corris, leads the way in developing environmentally friendly ways of using wind and water power, natural materials and traditional skills to benefit mankind.

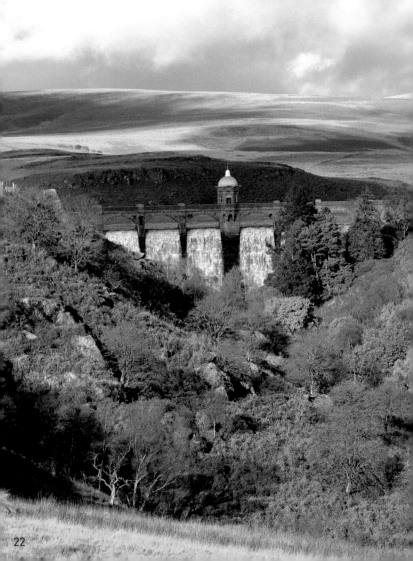

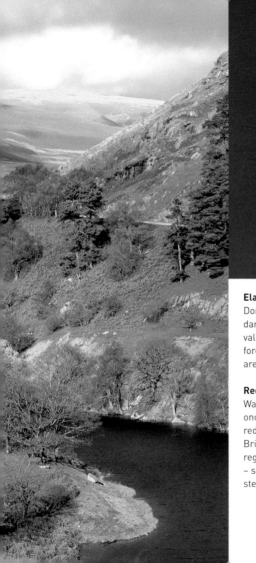

Elan Valley
Dominated by its impressive dam, this is one of several valleys in mid Wales where forestry and the supply of water are important activities.

Red Kite
Wales's largest bird of prey, once considered a pest, was reduced to the last few pairs in Britain. In recent decades it has regained territory in mid Wales – several hundred pairs are steadily extending their range.

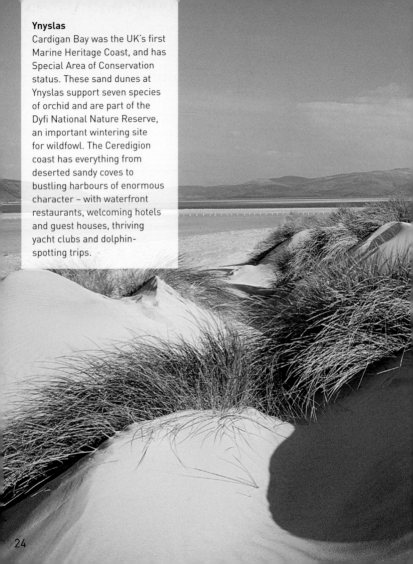

Ynyslas

Cardigan Bay was the UK's first Marine Heritage Coast, and has Special Area of Conservation status. These sand dunes at Ynyslas support seven species of orchid and are part of the Dyfi National Nature Reserve, an important wintering site for wildfowl. The Ceredigion coast has everything from deserted sandy coves to bustling harbours of enormous character – with waterfront restaurants, welcoming hotels and guest houses, thriving yacht clubs and dolphin-spotting trips.

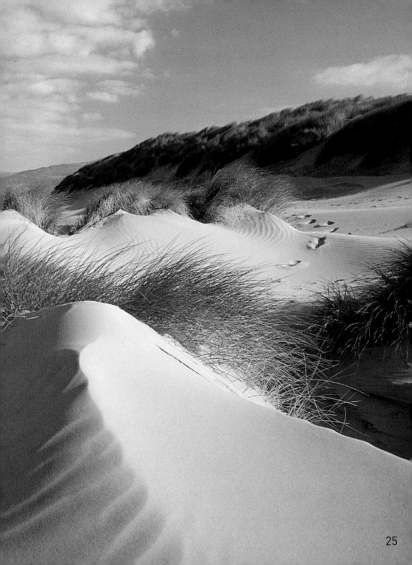

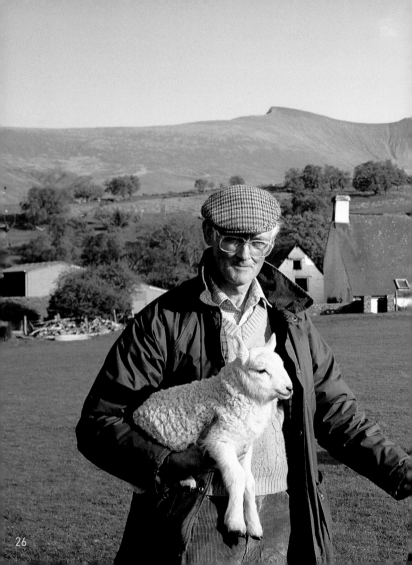

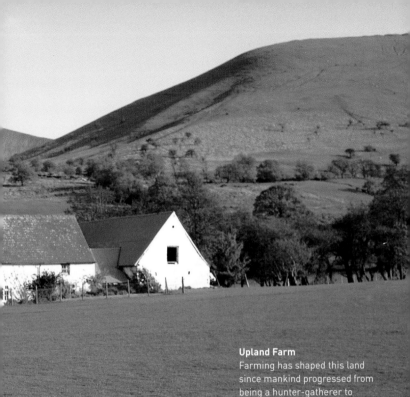

Upland Farm

Farming has shaped this land since mankind progressed from being a hunter-gatherer to keeping animals and growing crops. Local produce includes Welsh beef and lamb, salmon, game, honey, cider, cheese and pure, crystal-clear water piped from far underground. Taste and buy good food at the farmers' market held in Brecon each month – or visit the Royal Welsh Agricultural Show in Builth Wells during July.

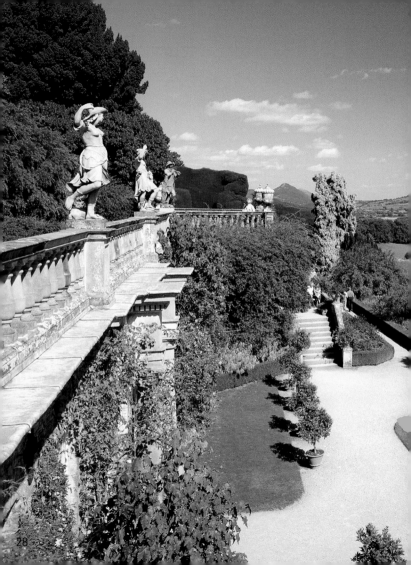

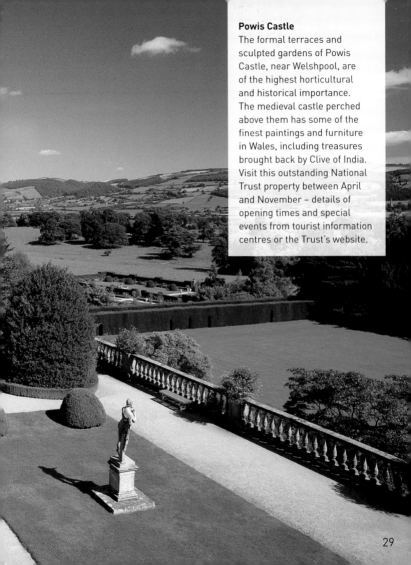

Powis Castle

The formal terraces and sculpted gardens of Powis Castle, near Welshpool, are of the highest horticultural and historical importance. The medieval castle perched above them has some of the finest paintings and furniture in Wales, including treasures brought back by Clive of India. Visit this outstanding National Trust property between April and November – details of opening times and special events from tourist information centres or the Trust's website.

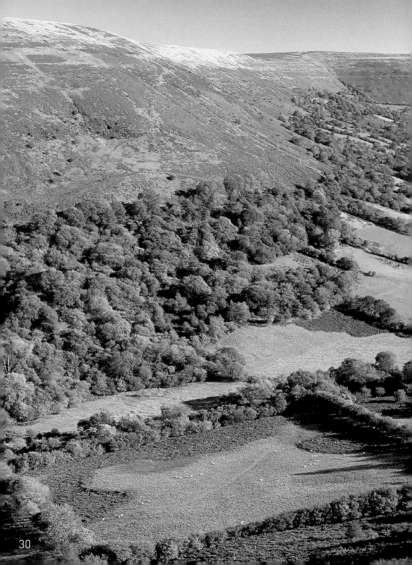

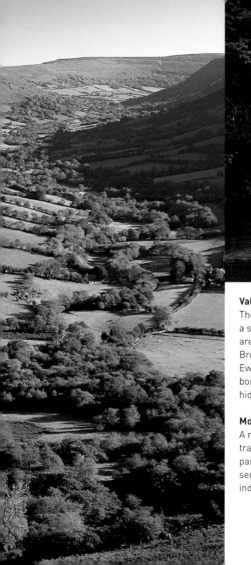

Vale of Ewyas

The Black Mountains, although a serious challenge for walkers, are less barren than the central Brecon Beacons. The Vale of Ewyas – on their eastern edge, bordering England – is a hidden gem.

Monmouth and Brecon Canal

A marvellous means of transport to find in a national park, this scenic canal once served the coal and iron industries.

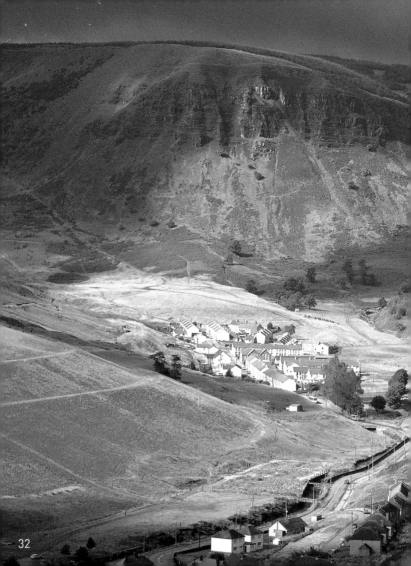

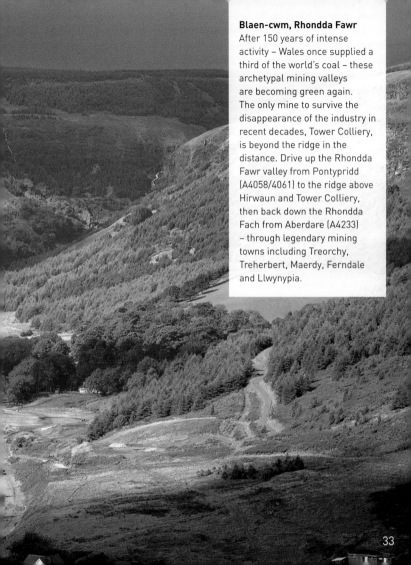

Blaen-cwm, Rhondda Fawr
After 150 years of intense
activity – Wales once supplied a
third of the world's coal – these
archetypal mining valleys
are becoming green again.
The only mine to survive the
disappearance of the industry in
recent decades, Tower Colliery,
is beyond the ridge in the
distance. Drive up the Rhondda
Fawr valley from Pontypridd
(A4058/4061) to the ridge above
Hirwaun and Tower Colliery,
then back down the Rhondda
Fach from Aberdare (A4233)
– through legendary mining
towns including Treorchy,
Treherbert, Maerdy, Ferndale
and Llwynypia.

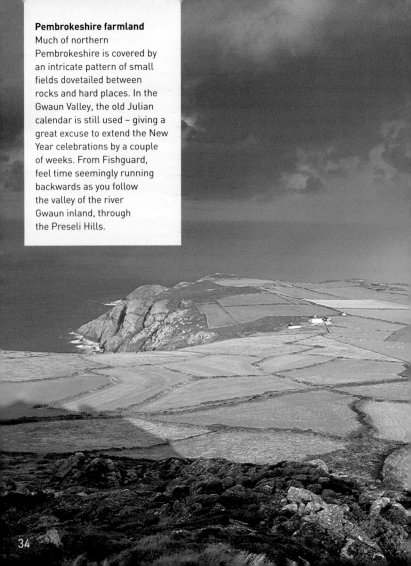

Pembrokeshire farmland
Much of northern Pembrokeshire is covered by an intricate pattern of small fields dovetailed between rocks and hard places. In the Gwaun Valley, the old Julian calendar is still used – giving a great excuse to extend the New Year celebrations by a couple of weeks. From Fishguard, feel time seemingly running backwards as you follow the valley of the river Gwaun inland, through the Preseli Hills.

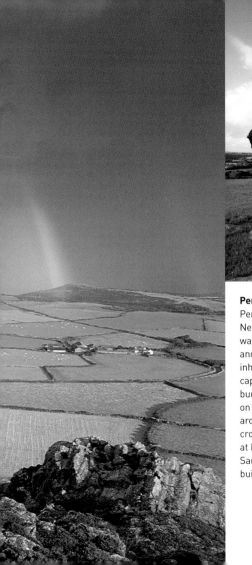

Pentre Ifan

Pembrokeshire has many Neolithic sites – the sea was both a food source and a highway for the early inhabitants of Wales. The capstone of the Pentre Ifan burial chamber, supported on pointed stone pillars, is around 13ft long. Seek out the cromlechs (stone monuments) at Pentre Ifan and Carreg Sampson, near Abercastle, built some 5,000 years ago.

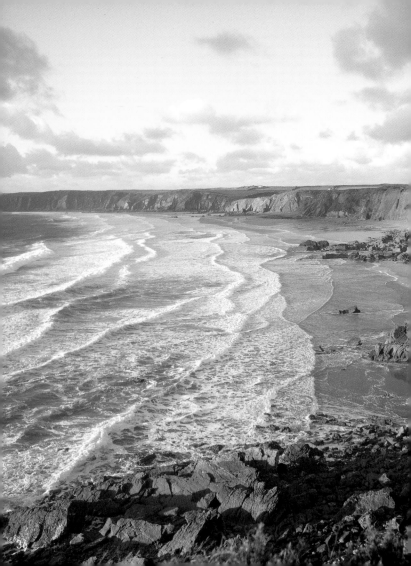

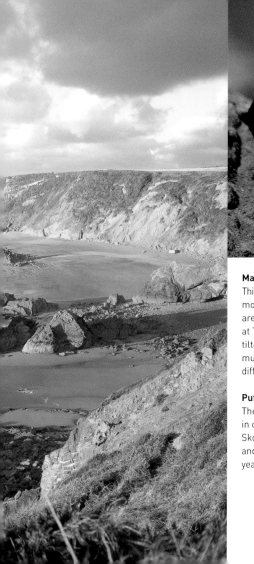

Marloes Sands

This is one of Pembrokeshire's most beautiful beaches. There are fascinating rock formations at Three Chimneys – where tilted bands of sandstone and mudstone have been eroded at different rates.

Puffin

These entertaining birds nest in colonies on Skokholm and Skomer from April to July – and spend the rest of the year at sea.

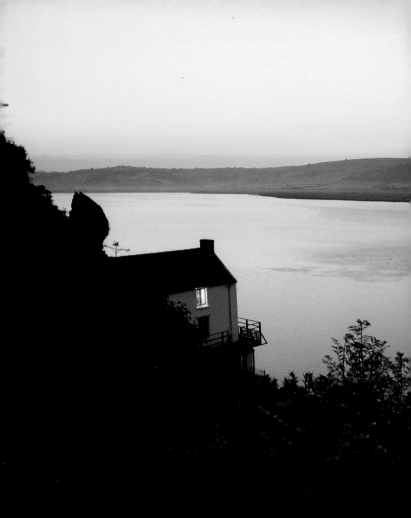

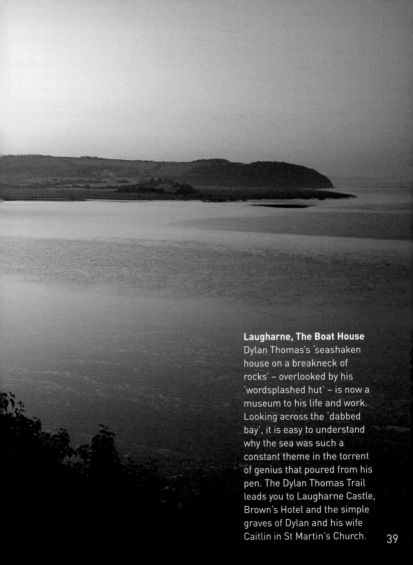

Laugharne, The Boat House
Dylan Thomas's 'seashaken house on a breakneck of rocks' – overlooked by his 'wordsplashed hut' – is now a museum to his life and work. Looking across the 'dabbed bay', it is easy to understand why the sea was such a constant theme in the torrent of genius that poured from his pen. The Dylan Thomas Trail leads you to Laugharne Castle, Brown's Hotel and the simple graves of Dylan and his wife Caitlin in St Martin's Church.

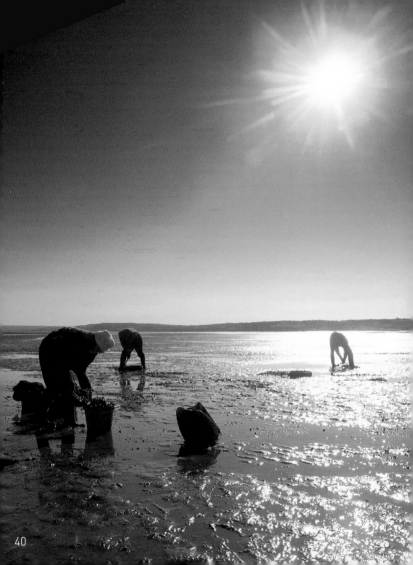

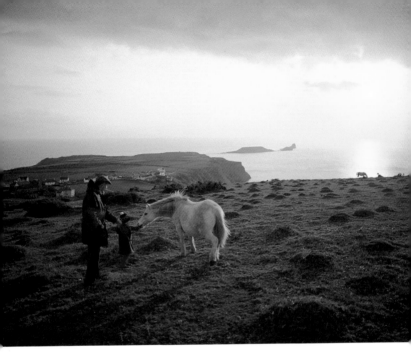

Penclawdd

The traditional, back-straining work of cockle picking continues at Penclawdd on the Loughor Estuary. Seafood features strongly at the Swansea Food Festival. Pop into Swansea's excellent indoor market and pick up the ingredients for Gower's quintessential breakfast – cockles, bacon and laverbread served with toast.

Rhossili

Gower is a maze of footpaths and bridlepaths waiting to be explored. The high cliffs convey a tremendous sense of space – and are great places to enjoy feeling windswept. Maps showing walks and cycle tracks are available locally – the Celtic Trail (National Cycle Network route 4) passes by.

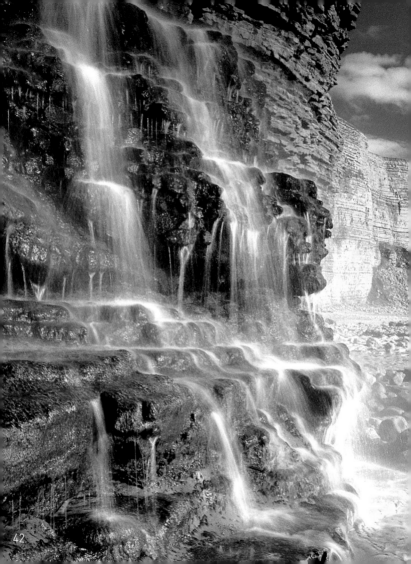

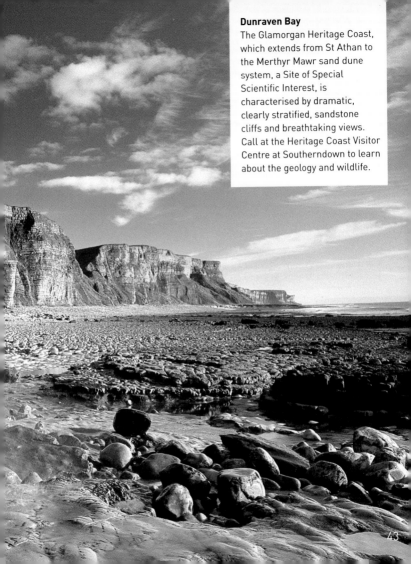

Dunraven Bay

The Glamorgan Heritage Coast, which extends from St Athan to the Merthyr Mawr sand dune system, a Site of Special Scientific Interest, is characterised by dramatic, clearly stratified, sandstone cliffs and breathtaking views. Call at the Heritage Coast Visitor Centre at Southerndown to learn about the geology and wildlife.

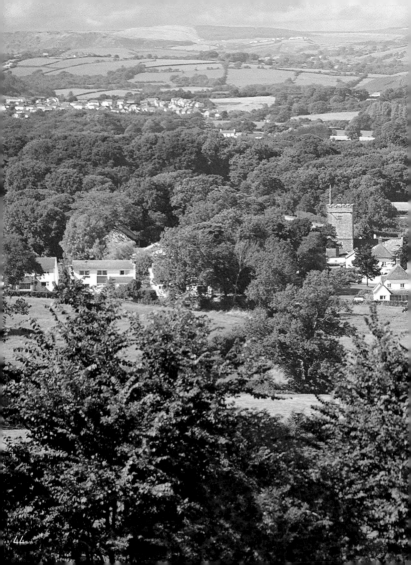

44

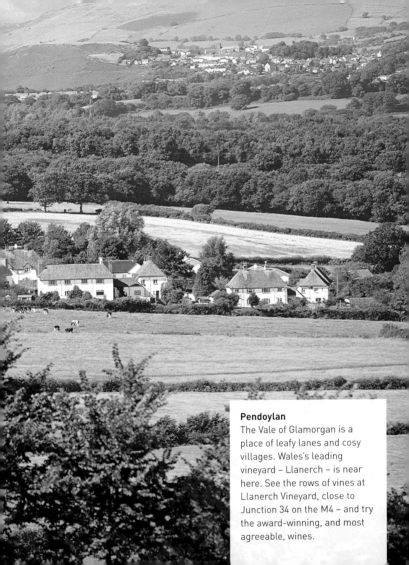

Pendoylan
The Vale of Glamorgan is a place of leafy lanes and cosy villages. Wales's leading vineyard – Llanerch – is near here. See the rows of vines at Llanerch Vineyard, close to Junction 34 on the M4 – and try the award-winning, and most agreeable, wines.

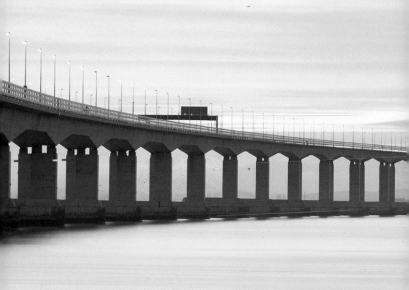

Second Severn Crossing

The newer of the two road
bridges over the Severn Estuary
symbolises the economic links
between Wales and the rest of
the UK and Europe. Tourists,
truckers and sports fans –
and Welsh people returning
home – understand, as they
cross, that they are arriving
somewhere special. Drive
over both Severn bridges to
experience the wide seascapes
or take the foot and cycle path
over the older bridge from
Severn View services.

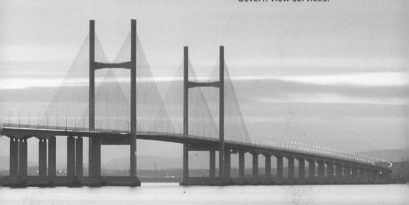

Cover: Porthdinllaen
Photo: David Williams.

Useful websites

www.visitwales.co.uk
www.ccw.gov.uk (National Trails)
www.snowdonia-npa.gov.uk
(Snowdonia National Park)
www.pembrokeshirecoast.org
(Pembrokeshire National Park)
www.visitbreconbeacons.org
(Brecon Beacons National Park)
www.photolibrarywales.co.uk
www.tourwales.org.uk
www.cadw.wales.gov.uk
www.nationaltrust.org.uk
www.graffeg.com

Published by Graffeg
First published 2008
© Graffeg 2008
ISBN 9781905582259

Graffeg, Radnor Court,
256 Cowbridge Road East,
Cardiff CF5 1GZ Wales UK.
www.graffeg.com
are hereby identified as the authors
of this work in accordance with
section 77 of the Copyrights,
Designs and Patents Act 1988.

A CIP Catalogue record for this book
is available from the British Library.

Designed and produced by Peter Gill
& Associates www.petergill.com

Copyright to all images in this book
© PhotolibraryWales.com / Steve
Benbow: 10, 11, 21, 44 / Andrew Davies:
36, 37 / Aled Hughes: 4 / Paul Kay: 8 /
John Kinsey: 31 / Jeremy Moore: IFC, 13,
23, 24, 30, 34, 42 / Dave Newbould: 12
/ Steve Peake: 15, 20 / Billy Stock: 46 /
Neil Turner: 32 / Chris Warren: 3, 7, 22,
28, 35 / David Williams: 16, 18 / Harry
Williams: 26, 38, 41 / David Woodfall: 14
/ Geraint Wyn Jones: IBC.

www.graffeg.com tel: 029 2037 7312